Dazzling Patterns

Color By Number
Anti Anxiety Coloring Book For Adults
For Relaxation and Meditation

BLACK BACKGROUND

BY COLOR QUESTOPIA

Copyright © 2021

All rights reserved. No part of this publication may be reproduced, distributed, or transmitted in any form or by any means, including photocopying, recording, or other electronic or mechanical methods, without the prior written permission of the publisher

OUR COLOR PALETTE TIPS

1. Colors corresponding to each number are shown on the back cover of the book - NEW- There are only 25 colors total in this book, with one "Flesh Tone" color where you can choose any flesh tone!

Each number corresponds to a color shown on the back of the book. There will sometimes be an asterisk (*) that corresponds to "Any Flesh Tone."

To the left of each image, there's a list of colors used within that particular image. Simply match the numbers on the images to the colors on the list. If you tear a page out of the book, you can simply use the color key on the back of the book to match your colors. If you don't have an exact color match, that's totally fine. Feel free to use a similar color or shade. Although this is a color by number book, it's completely okay to get creative and change up the colors listed. You can let your imagination run wild, and color the images with whichever colors you like and have. The numbers are here to be a guide and to allow you to color without having to focus your energy on choosing colors.

- 2. If there are any spaces on an image without a number, you can go ahead and leave that space white (blank)

 You can leave any space without a number white (blank), or you can fill that space in with any color you like. Another idea is to color that space in with a white color (for example, if you'd like to use a shiny white or a different shade of white on an image.)
- 3. Bonus Images may have a slightly different color palette
 Because the bonus images are from previous books with slightly
 different color palettes, they may include colors that aren't on
 the back of this book. Simply match them the best that you can,
 or choose completely different colors if you like. You are the
 artist and you are allowed to relax and enjoy!

COLOR BY NUMBER TIPS

1. Relax and have fun

Let your cares slip away as you color the images. Take your time. Coloring is a meditative activity and there's no wrong way to do it. Feel free to color as you listen to music, watch TV, lounge in bed- do whatever relaxes you most! You can also color while you're out and about- on the train or at a cafe- take the book with you anywhere you go. Coloring is therapeutic and is great for stress relief and relaxation!

2. Choose your coloring tools

Everyone has their favorite coloring markers, crayons, pencils, pens- even paints! Feel free to color with any tool that you like! If you choose markers or paints, we recommend putting a blank sheet of paper or cardboard behind each image, so that your colors don't run onto the next image.

3. Test out your colors

Feel free to test out your colors on our Color Test Sheets at the back, and use our Custom Color Chart to make the color choices your own!

Relax and Enjoy!

- 8. Red
- 10. Orange
- 12. Yellow
- 14. Light Green
- 15. Green
- 17. Aqua Green
- 19. Blue
- 20. Dark Blue
- 21. Lilac
- 22. Violet
- 23. Pink
- 24. Vivid Pink

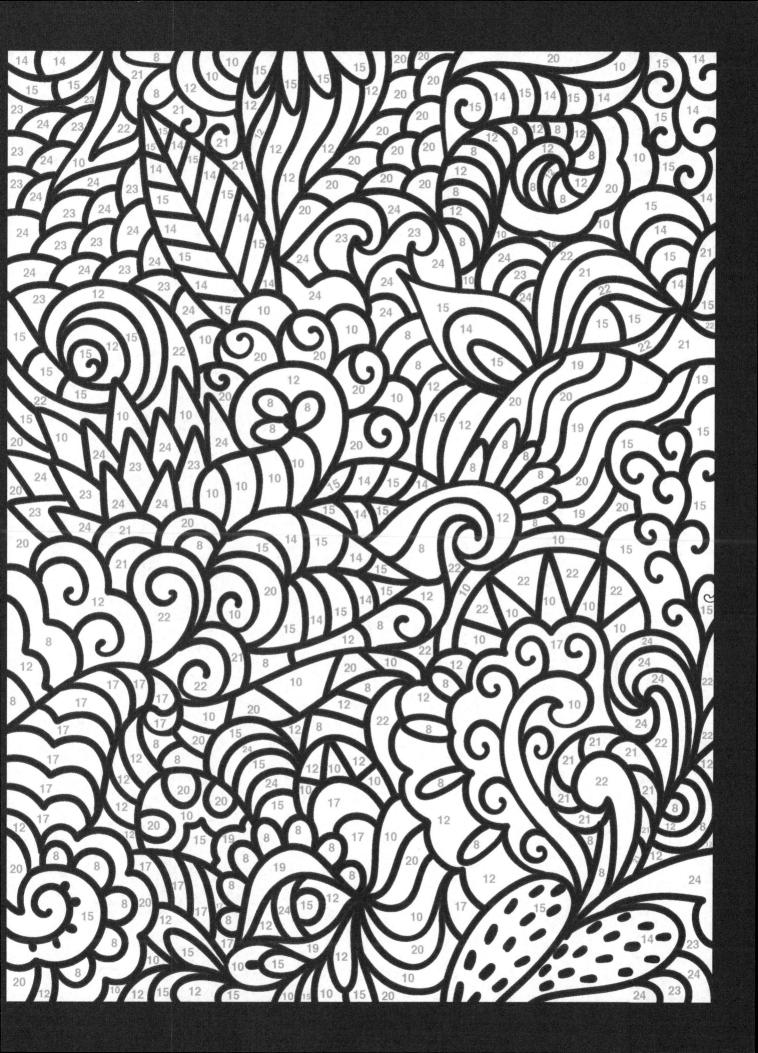

- 8. Red
- 10. Orange
- 11. Light Yellow
- 12. Yellow
- 14. Light Green
- 15. Green
- 17. Aqua Green
- 20. Dark Blue
- 22. Violet
- 23. Pink
- 24. Vivid Pink

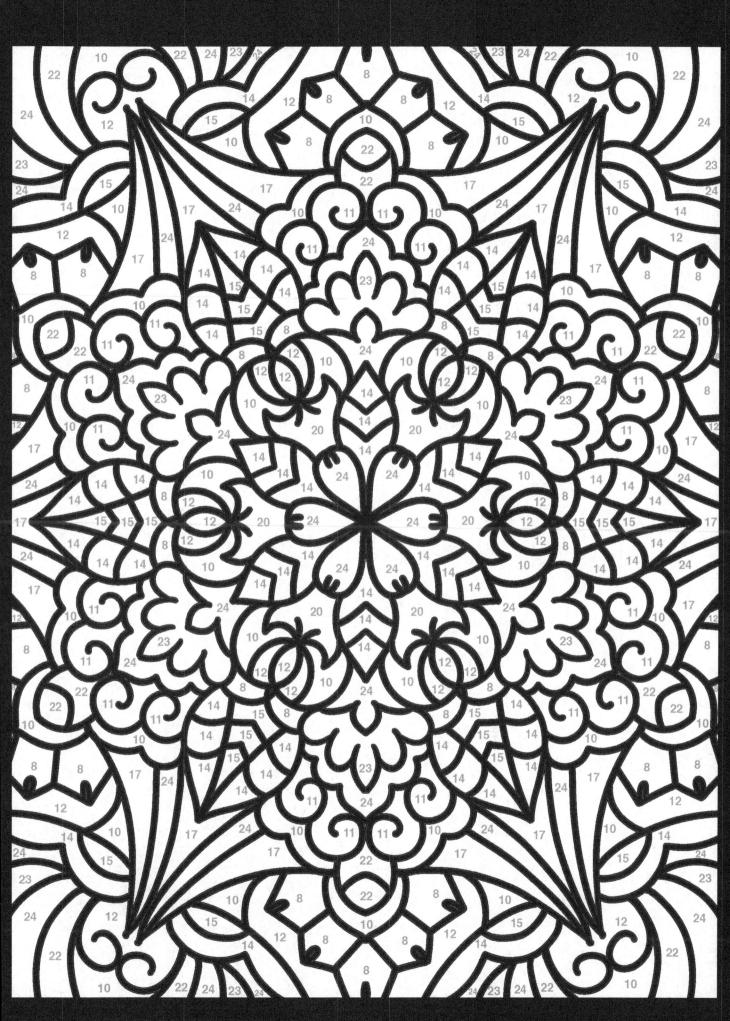

- 6. Tan
- 8. Red
- 10. Orange
- 12. Yellow
- 14. Light Green
- 15. Green
- 16. Dark Green
- 17. Aqua Green
- 18. Light Blue
- 20. Dark Blue
- 21. Lilac
- 22. Violet
- 23. Pink
- 24. Vivid Pink

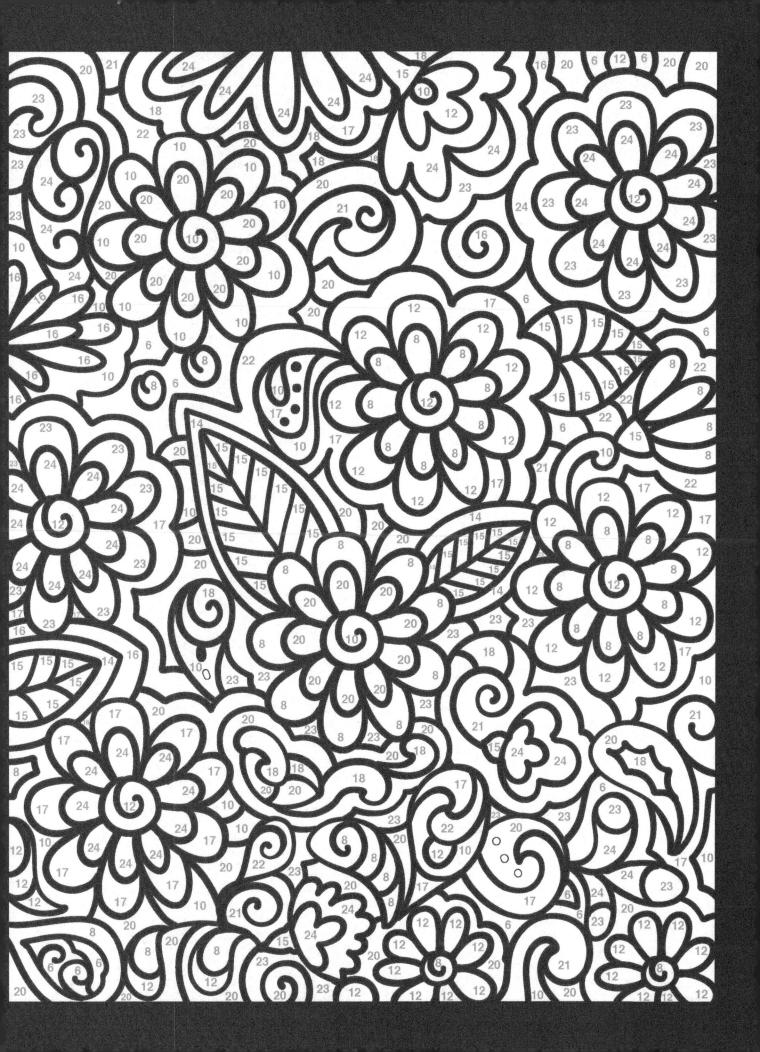

- 10. Orange
- 12. Yellow
- 14. Light Green
- 15. Green
- 16. Dark Green
- 17. Aqua Green
- 18. Light Blue
- 20. Dark Blue
- 23. Pink
- 24. Vivid Pink

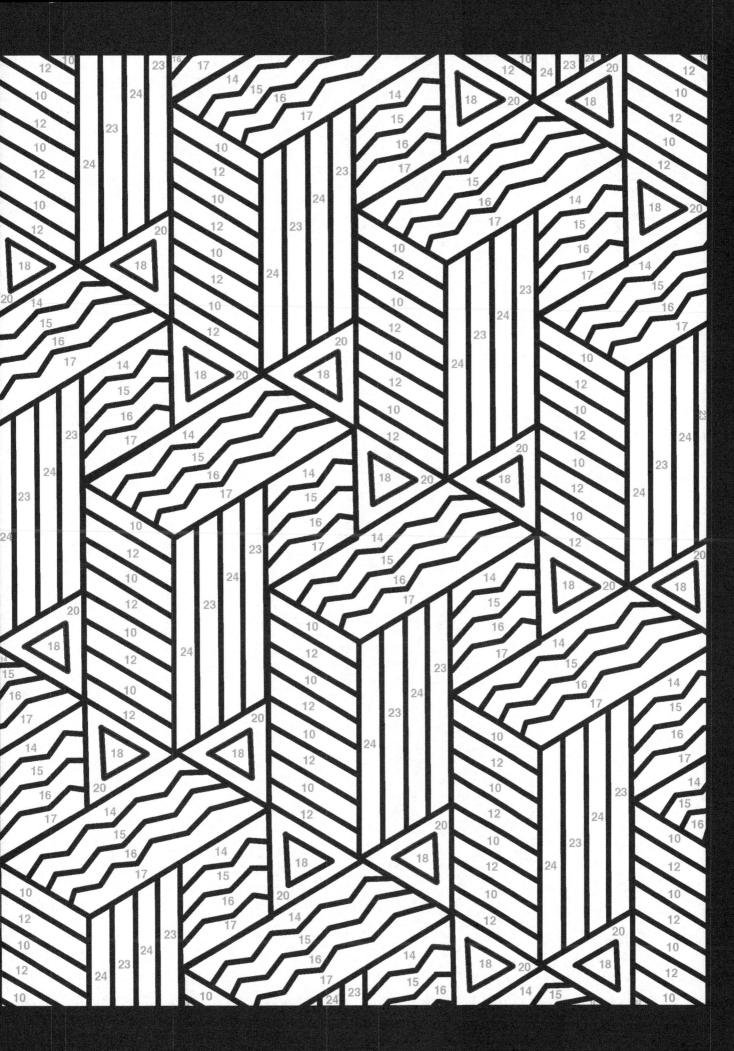

- 8. Red
- 10. Orange
- 12. Yellow
- 13. Golden Yellow
- 14. Light Green
- 15. Green
- 16. Dark Green
- 17. Aqua Green
- 18. Light Blue
- 19. Blue
- 20. Dark Blue
- 21. Lilac
- 22. Violet
- 23. Pink

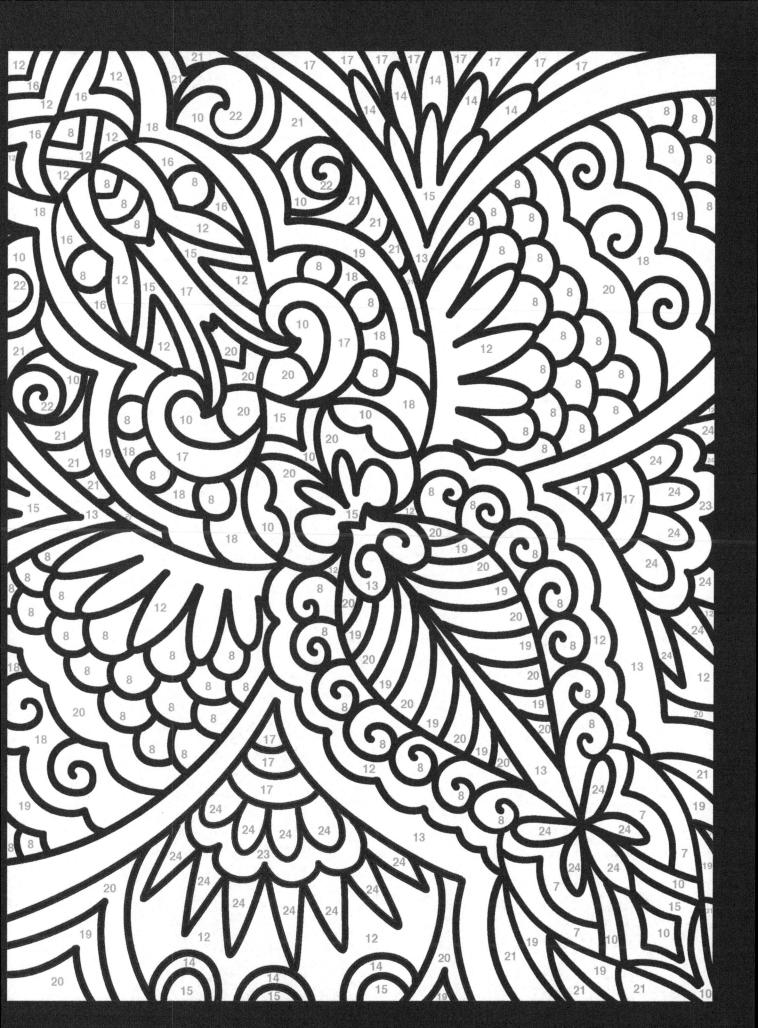

- 7. Peach
- 8. Red
- 9. Orange Red
- 10. Orange
- 12. Yellow
- 13. Golden Yellow
- 15. Green
- 16. Dark Green
- 17. Aqua Green
- 20. Dark Blue
- 21. Lilac
- 22. Violet
- 23. Pink
- 24. Vivid Pink

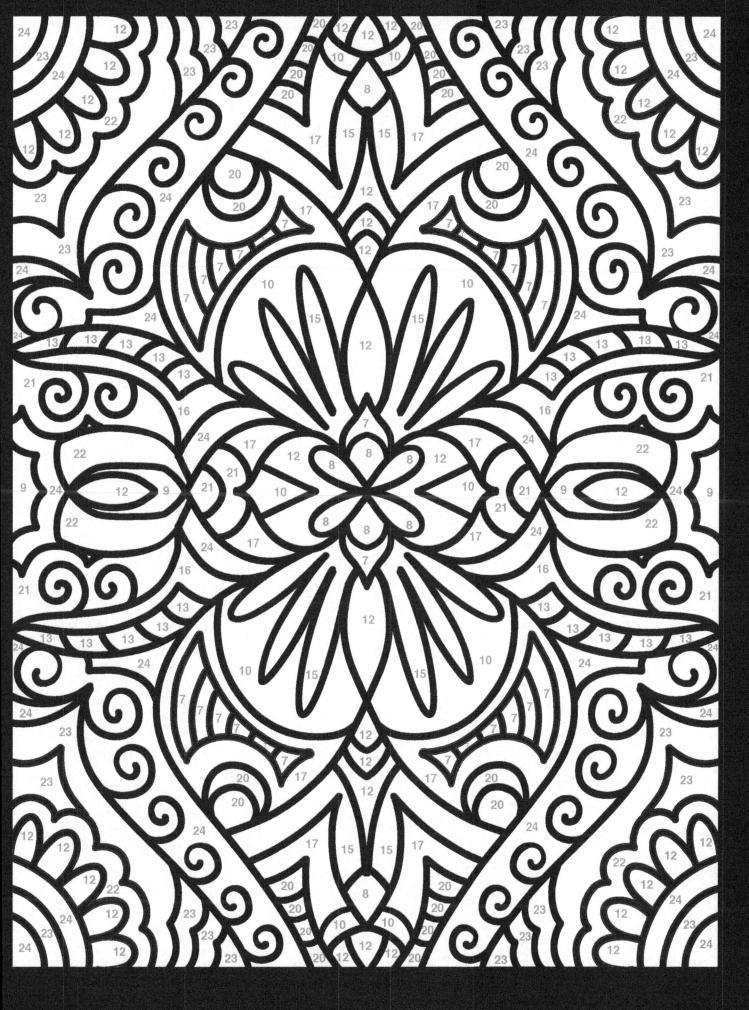

- 8. Red
- 10. Orange
- 12. Yellow
- 14. Light Green
- 15. Green
- 16. Dark Green
- 17. Aqua Green
- 20. Dark Blue
- 24. Vivid Pink

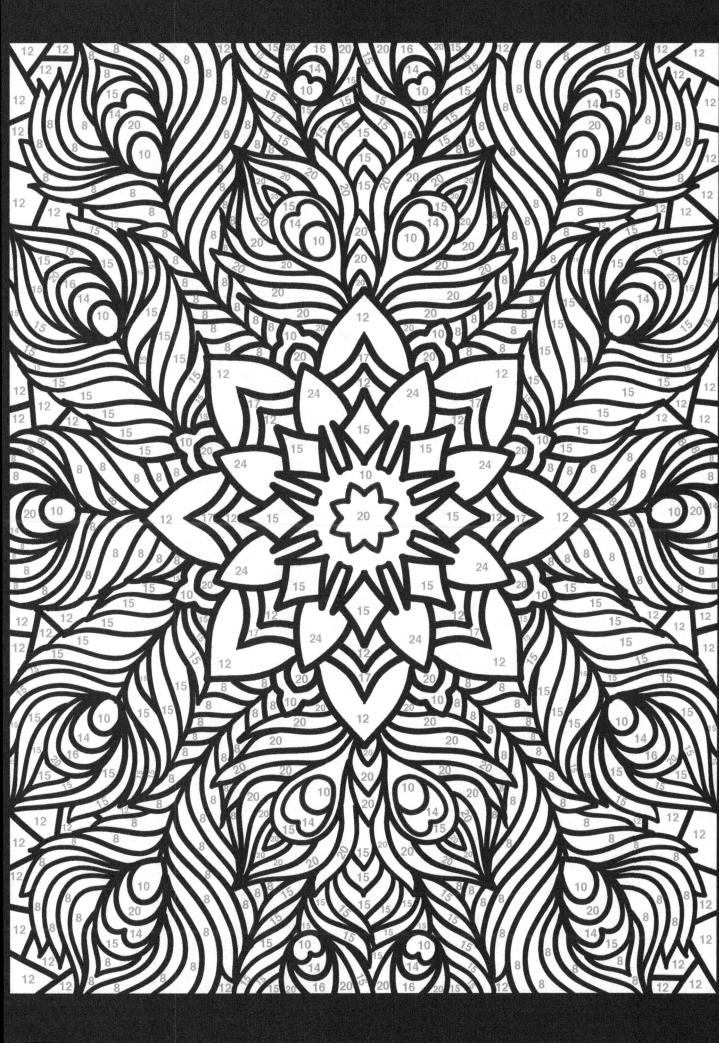

- 8. Red
- 9. Orange Red
- 12. Yellow
- 17. Aqua Green
- 18. Light Blue
- 20. Dark Blue

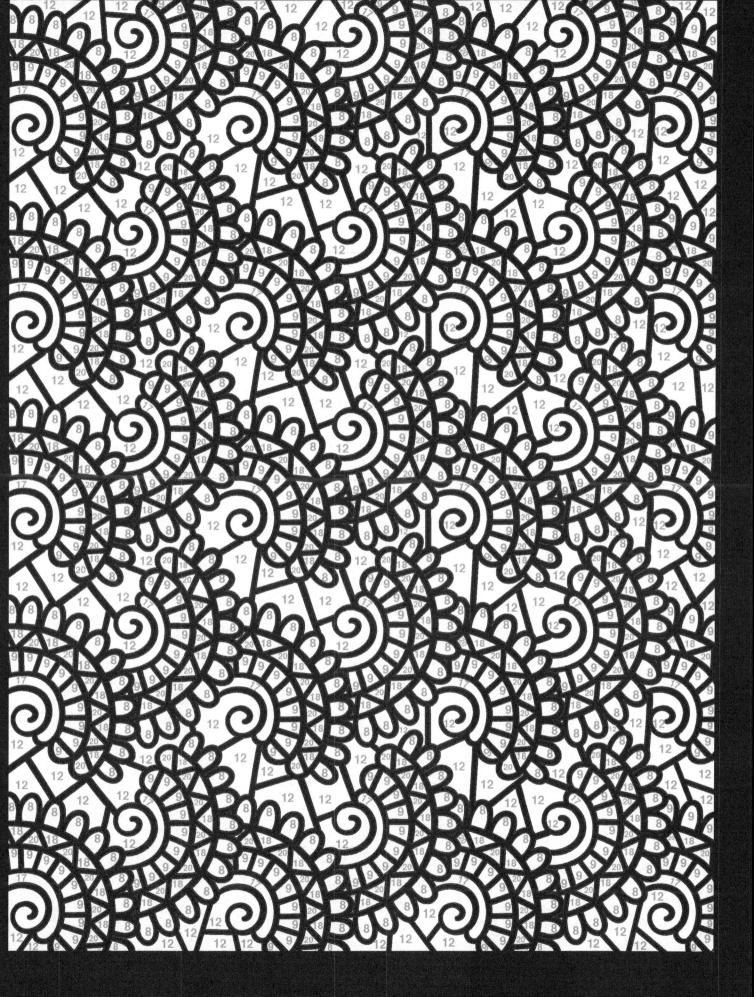

- 6. Tan
- 8. Red
- 10. Orange
- 12. Yellow
- 14. Light Green
- 15. Green
- 16. Dark Green
- 17. Aqua Green
- 18. Light Blue
- 20. Dark Blue
- 21. Lilac
- 22. Violet
- 23. Pink
- 24. Vivid Pink

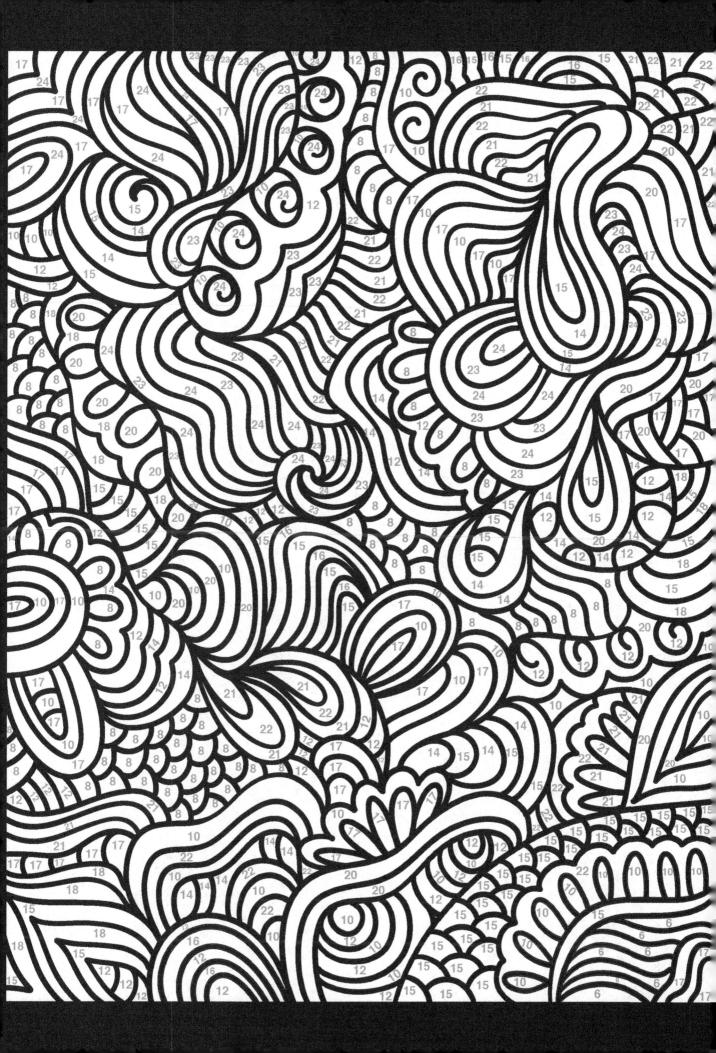

- 7. Peach
- 8. Red
- 9. Orange Red
- 10. Orange
- 12. Yellow
- 15. Green
- 17. Aqua Green
- 18. Light Blue
- 19. Blue
- 20. Dark Blue
- 21. Lilac
- 22. Violet
- 24. Vivid Pink

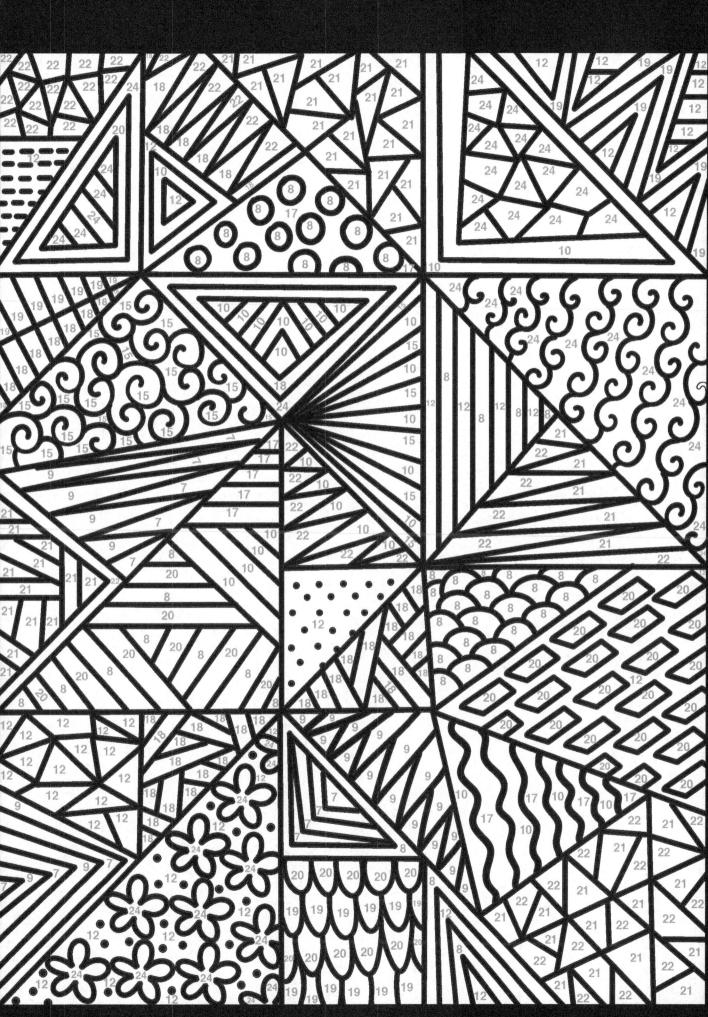

- 8. Red
- 9. Orange Red
- 10. Orange
- 11. Light Yellow
- 14. Light Green
- 15. Green
- 17. Aqua Green
- 20. Dark Blue
- 22. Violet
- 23. Pink
- 24. Vivid Pink

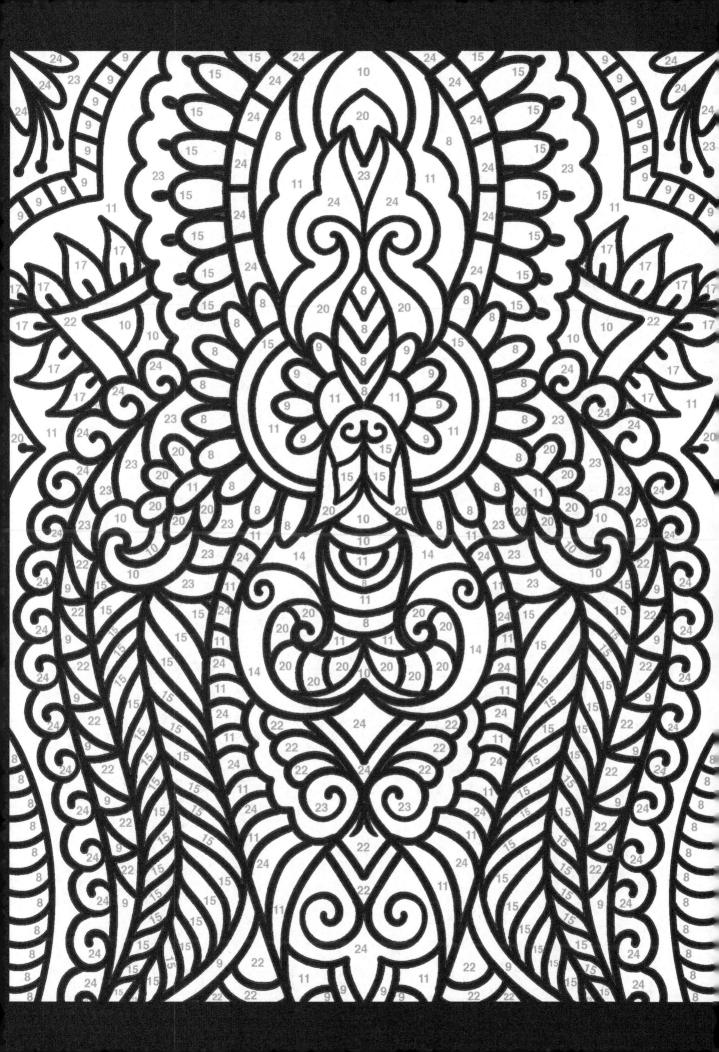

- 7. Peach
- 8. Red
- 9. Orange Red
- 10. Orange
- 12. Yellow
- 14. Light Green
- 15. Green
- 17. Aqua Green
- 19. Blue
- 22. Violet
- 24. Vivid Pink

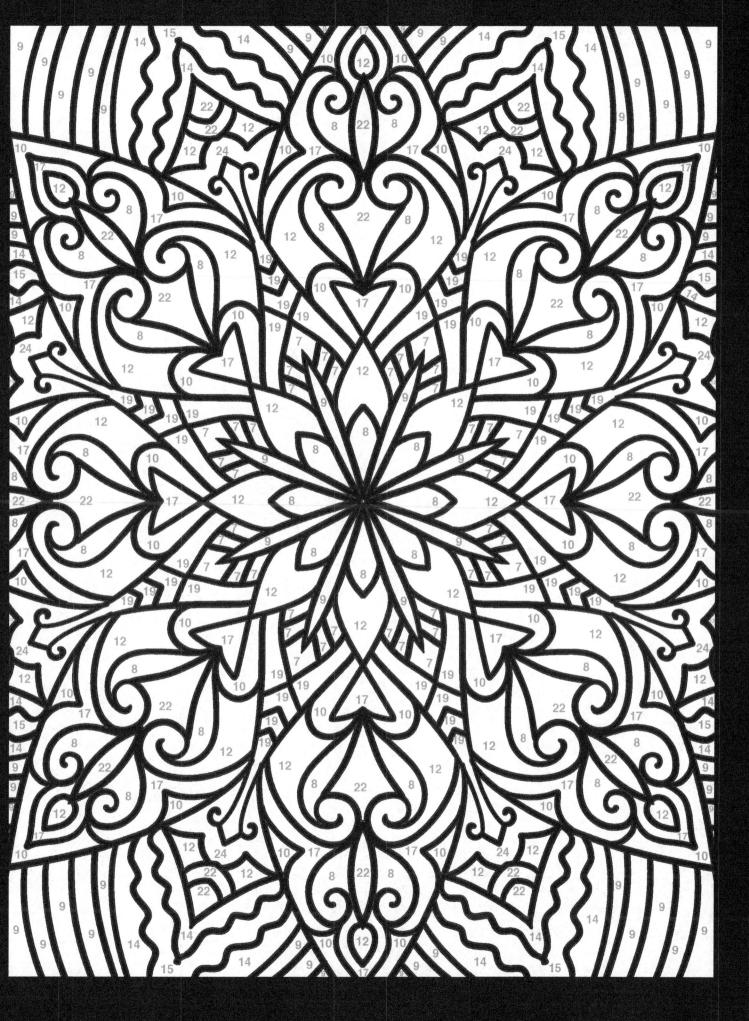

- 6. Tan
- 7. Peach
- 8. Red
- 10. Orange
- 12. Yellow
- 15. Green
- 17. Aqua Green
- 19. Blue
- 22. Violet
- 23. Pink
- 24. Vivid Pink

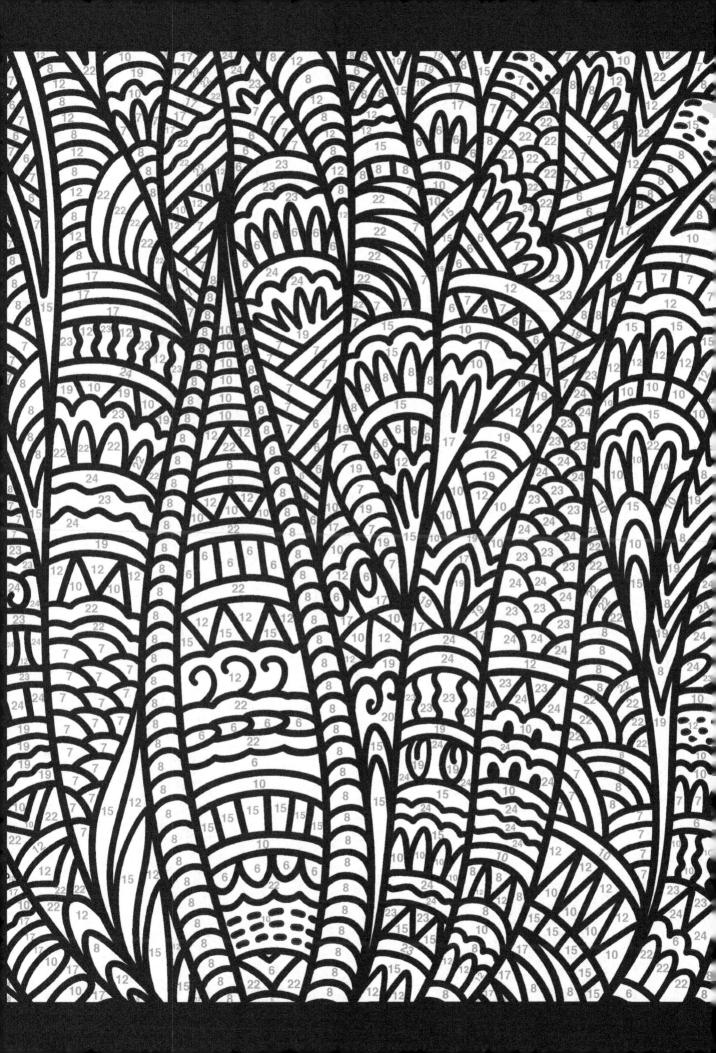

- 7. Peach
- 8. Red
- 10. Orange
- 12. Yellow
- 15. Green
- 17. Aqua Green
- 19. Blue
- 22. Violet
- 24. Vivid Pink

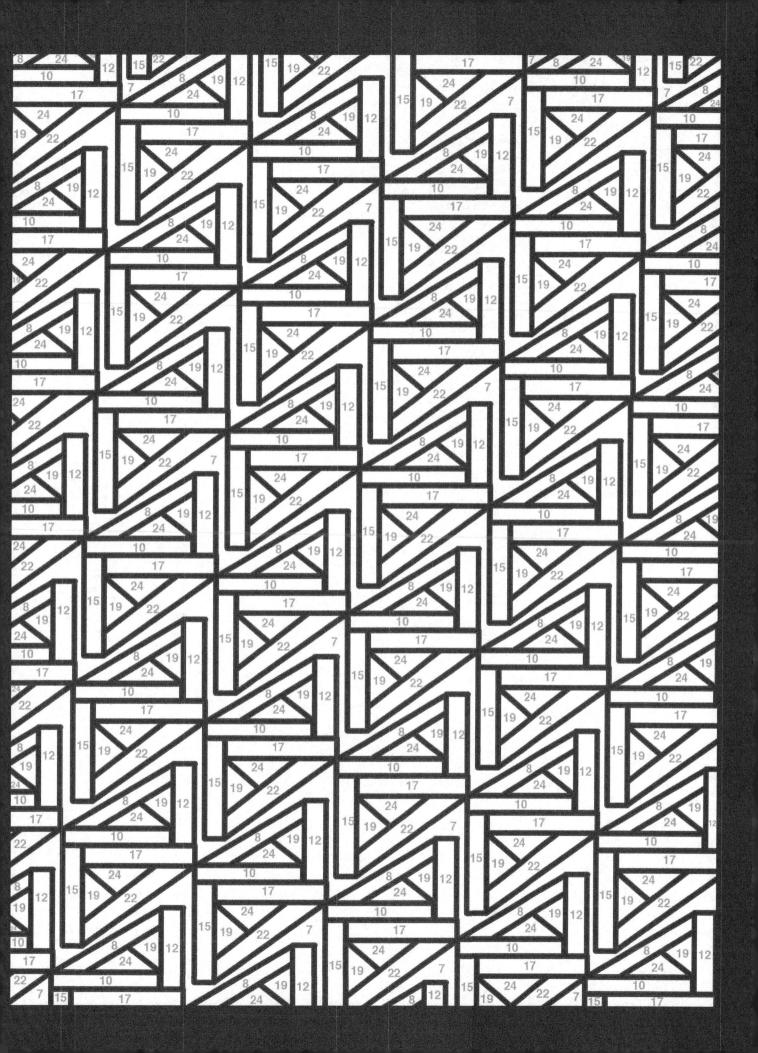

- 8. Red
- 10. Orange
- 12. Yellow
- 15. Green
- 17. Aqua Green
- 18. Light Blue
- 20. Dark Blue
- 23. Pink
- 24. Vivid Pink

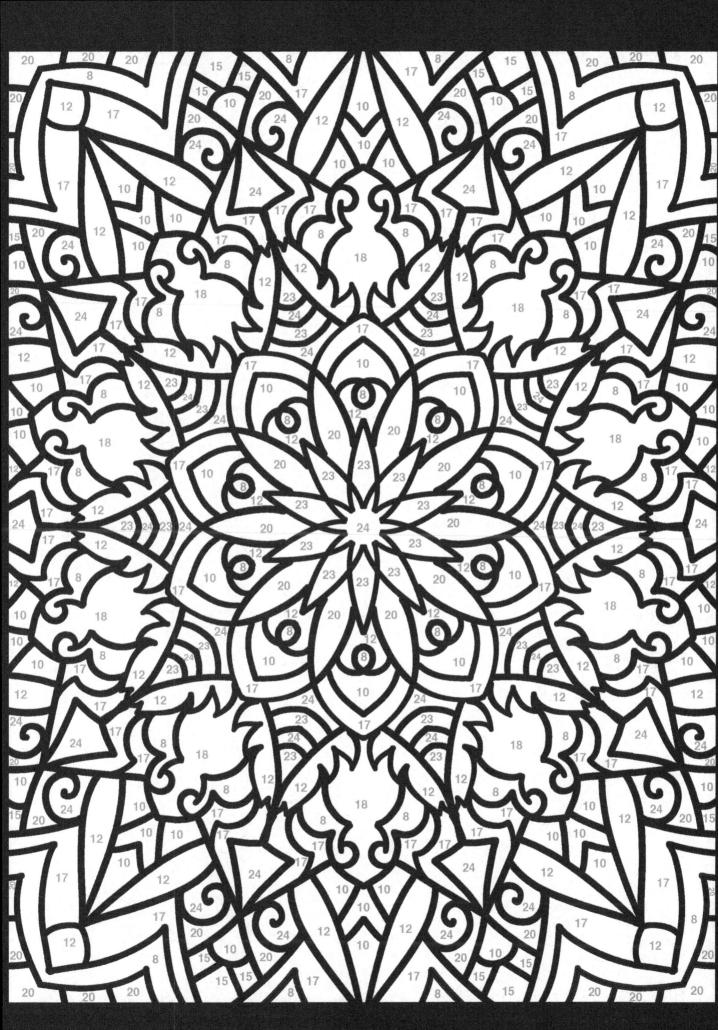

- 7. Peach
- 8. Red
- 10. Orange
- 12. Yellow
- 14. Light Green
- 18. Light Blue
- 19. Blue
- 21. Lilac
- 22. Violet
- 24. Vivid Pink

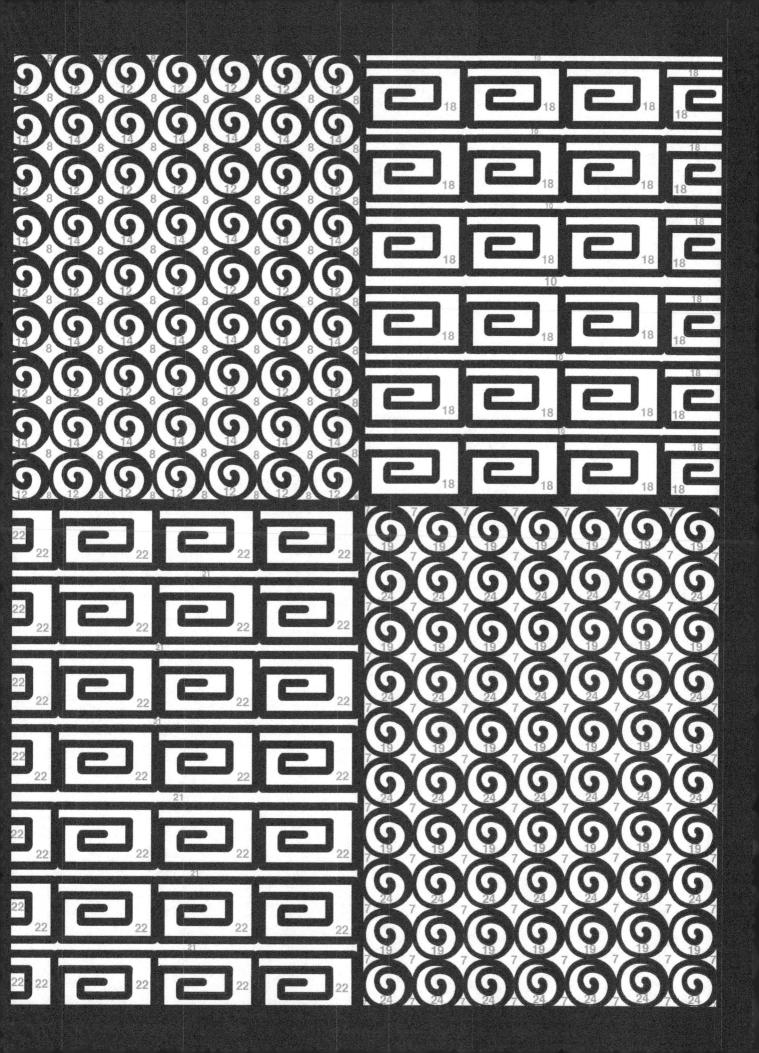

- 2. Gray
- 3. Dark Gray
- 4. Brown
- 5. Dark Brown
- 6. Tan
- 7. Peach
- 8. Red
- 10. Orange
- 12. Yellow
- 15. Green
- 16. Dark Green
- 18. Light Blue
- 19. Blue

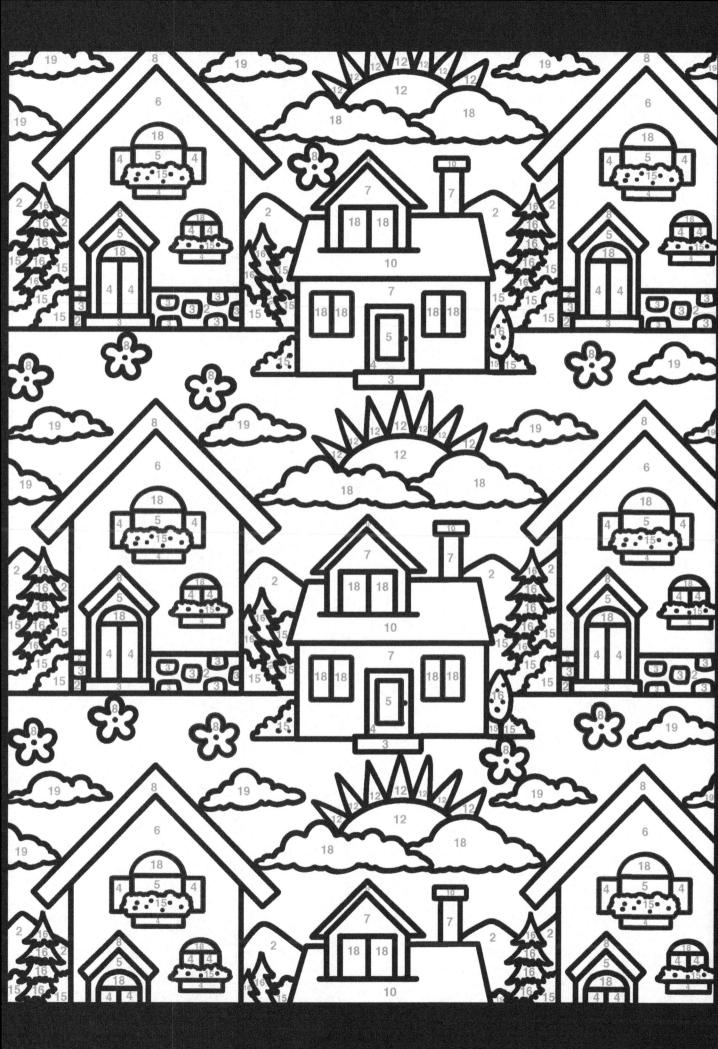

- 8. Red
- 10. Orange
- 12. Yellow
- 14. Light Green
- 17. Aqua Green
- 18. Light Blue
- 19. Blue
- 20. Dark Blue
- 22. Violet
- 23. Pink
- 24. Vivid Pink

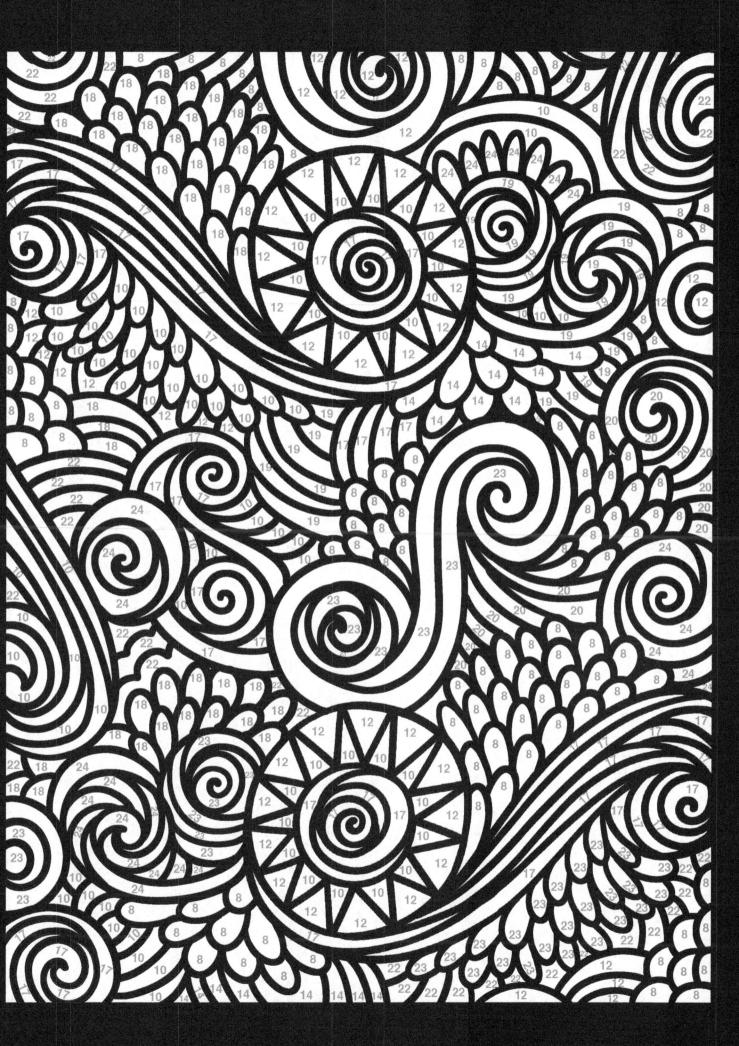

- 6. Tan
- 7. Peach
- 8. Red
- 10. Orange
- 12. Yellow
- 14. Light Green
- 15. Green
- 17. Aqua Green
- 20. Dark Blue
- 23. Pink
- 24. Vivid Pink

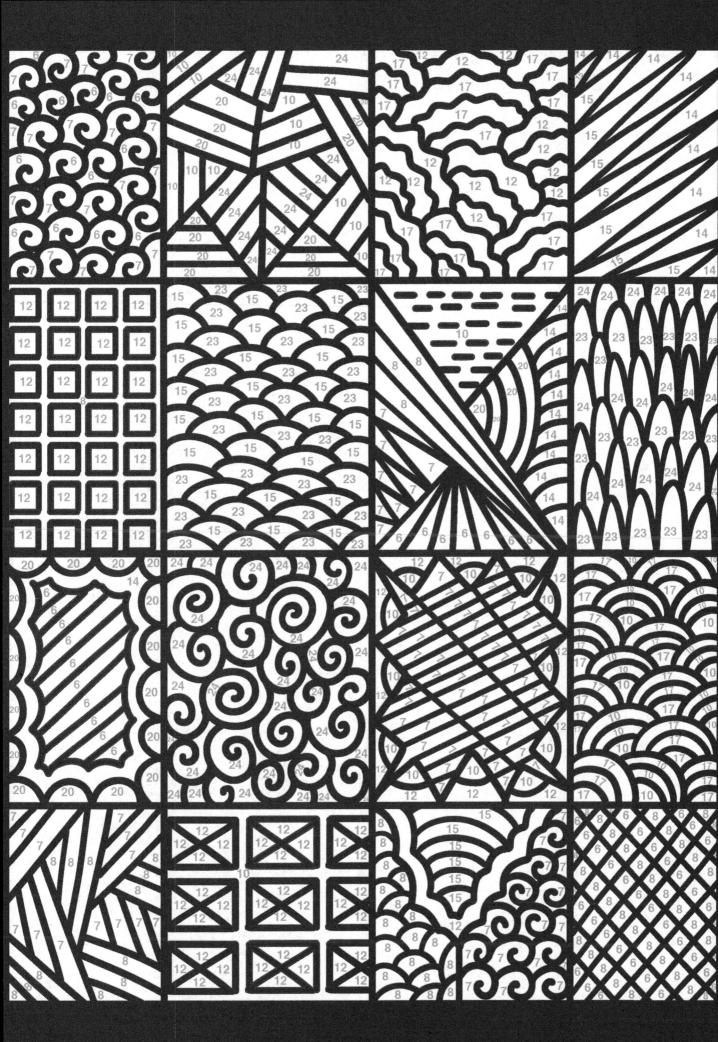

- 7. Peach
- 8. Red
- 10. Orange
- 12. Yellow
- 15. Green
- 17. Aqua Green
- 24. Vivid Pink

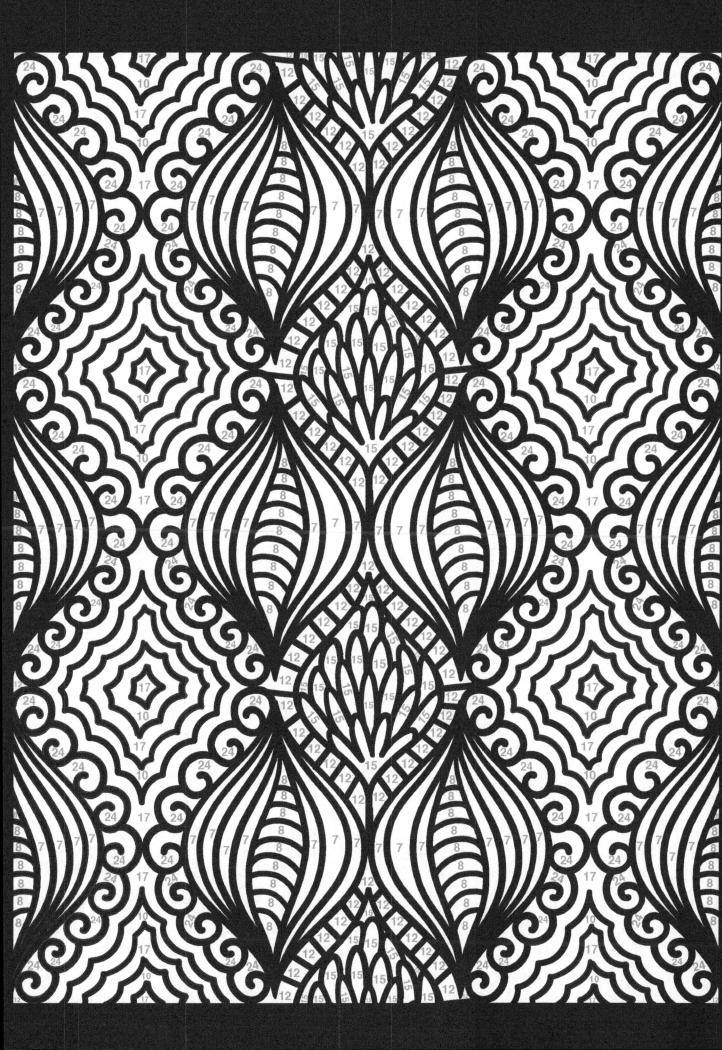

- 1. Black
- 8. Red
- 9. Orange Red
- 10. Orange
- 12. Yellow
- 15. Green
- 17. Aqua Green
- 18. Light Blue
- 20. Dark Blue
- 23. Pink
- 24. Vivid Pink

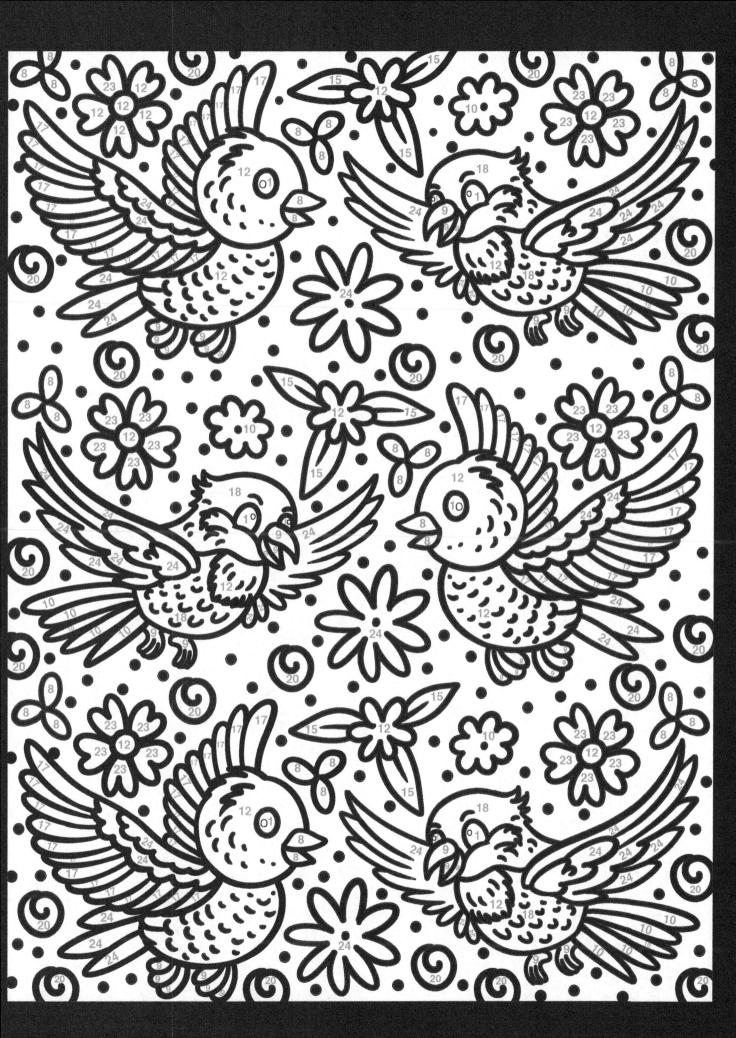

- 6. Tan
- 7. Peach
- 8. Red
- 9. Orange Red
- 10. Orange
- 11. Light Yellow
- 13. Golden Yellow
- 14. Light Green
- 16. Dark Green
- 18. Light Blue
- 22. Violet
- 23. Pink
- 24. Vivid Pink

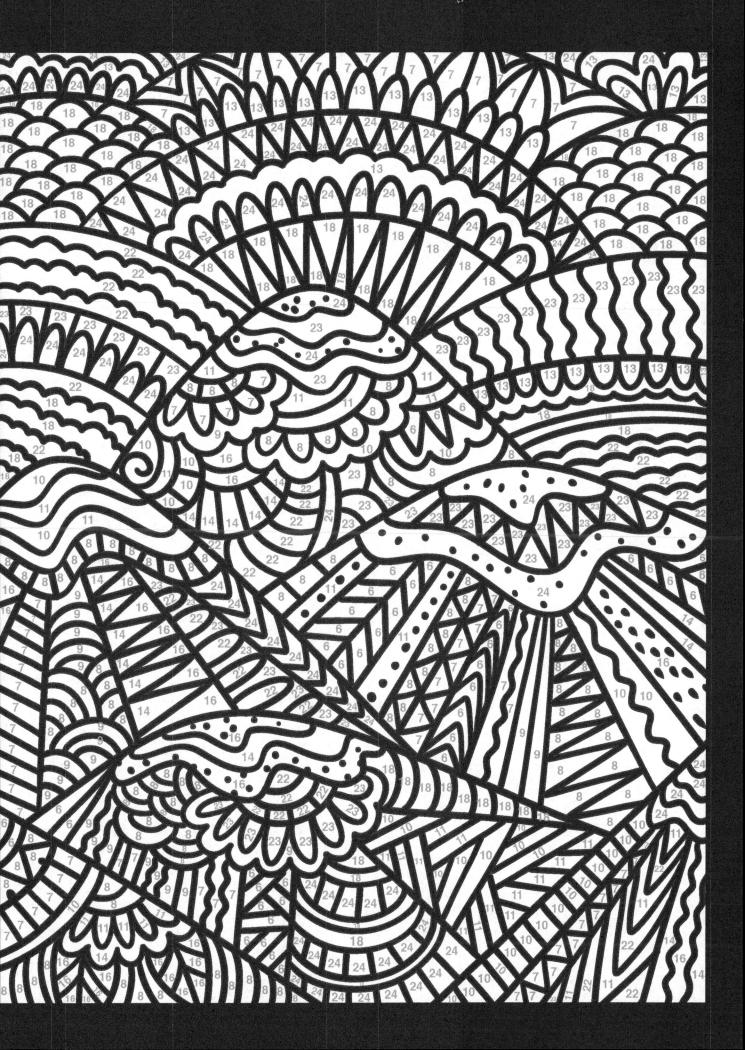

- 6. Tan
- 7. Peach
- 8. Red
- 9. Orange Red
- 12. Yellow
- 14. Light Green
- 15. Green
- 19. Blue
- 21. Lilac
- 23. Pink
- 24. Vivid Pink

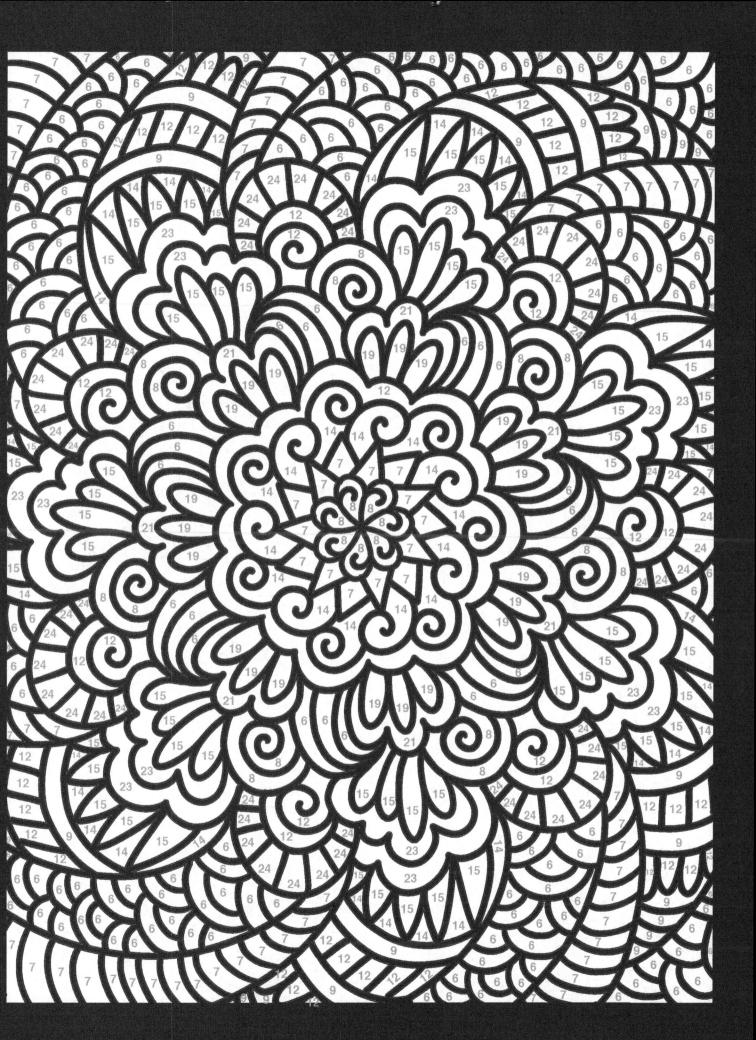

- 6. Tan
- 7. Peach
- 8. Red
- 9. Orange Red
- 11. Light Yellow
- 14. Light Green
- 16. Dark Green
- 18. Light Blue
- 20. Dark Blue
- 21. Lilac
- 23. Pink
- 24. Vivid Pink

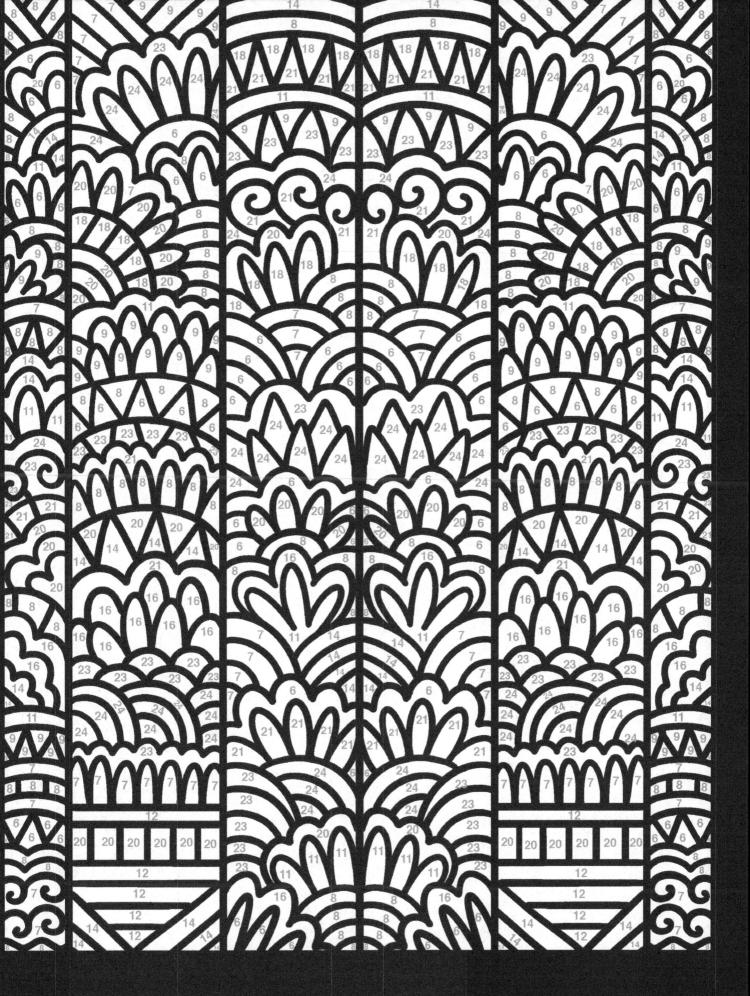

- 7. Peach
- 8. Red
- 10. Orange
- 12. Yellow
- 14. Light Green
- 17. Aqua Green
- 20. Dark Blue
- 21. Lilac
- 23. Pink
- 24. Vivid Pink

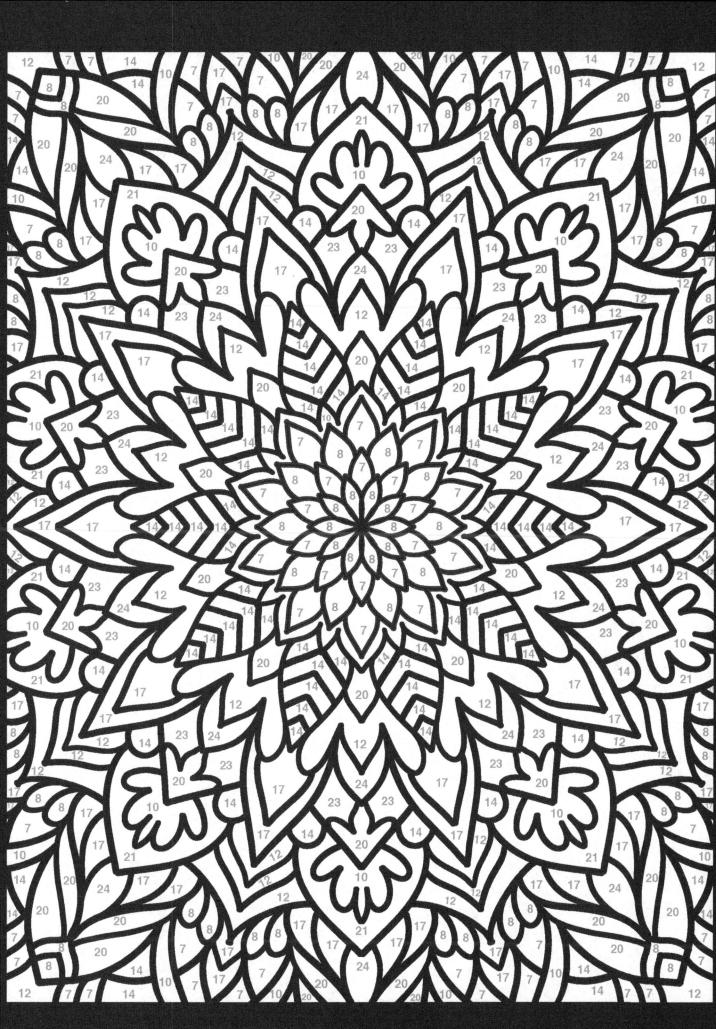

ENICY BONUS
IMAGES FROM SOME
OF OUR
OTHER FUN
COLOR BY NUMBER
BOOKSI

FIND ALL OF OUR BOOKS
O'N AMAZON

왕고일 소문에 남아 생각이 마쳤다. 이동, 왕은 기사 사랑 캠프라 보다를 모았다며 그는 그일

Interior Design BLACK BACKGROUND Color By Number Adult Coloring Book

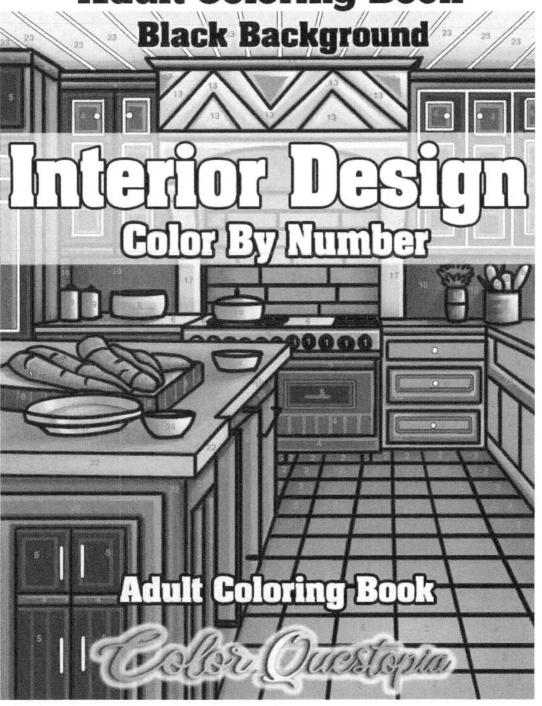

- 2. Gray
- 4. Brown
- 6. Tan
- 8. Red
- 10. Orange
- 12. Yellow
- 14. Light Green
- 15. Green
- 18. Light Blue
- 22. Violet
- 23. Pink

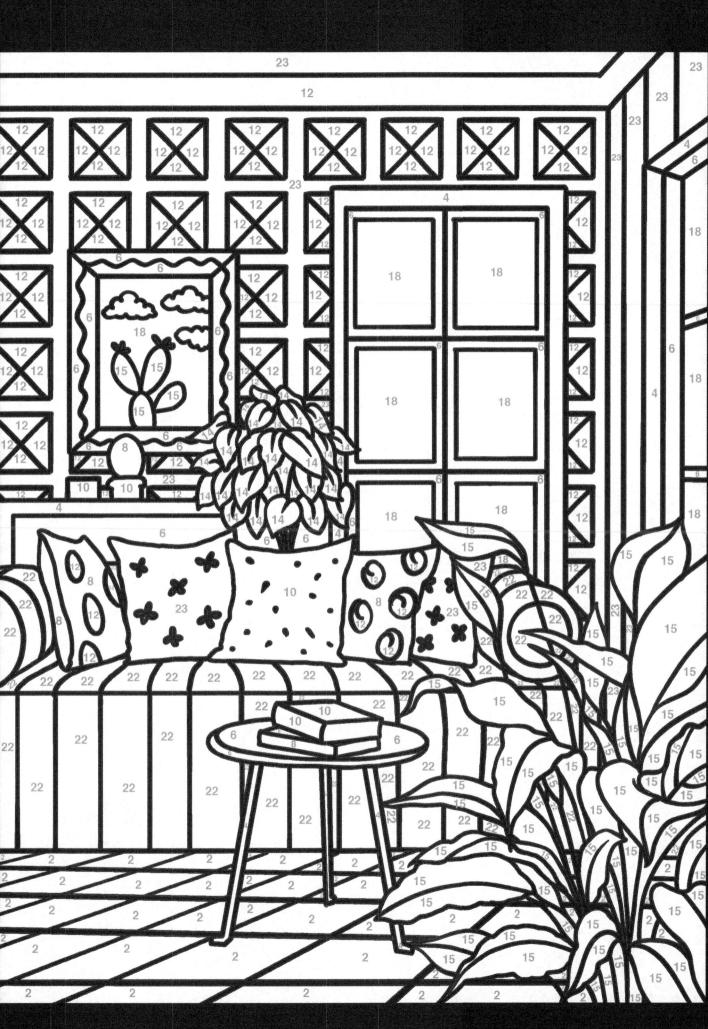

Inspirational Quotes BLACK BACKGROUND

Large Print Adult Color By Number Coloring Book for Adults

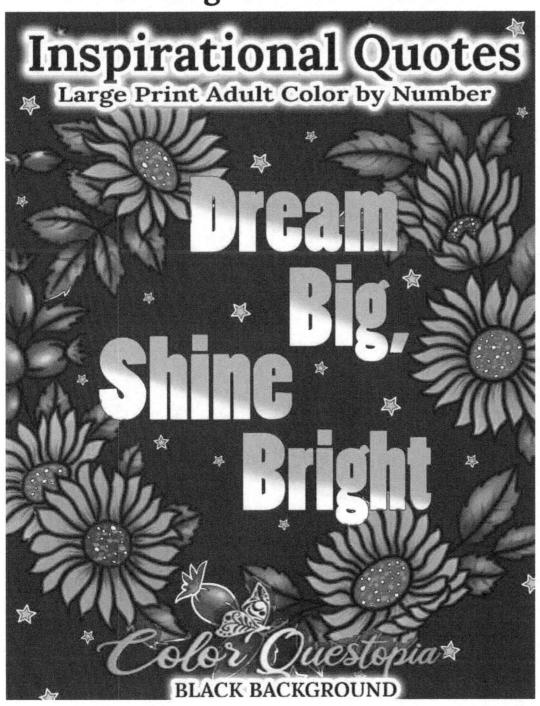

- 2. Gray
- 3. Dark Gray
- 5. Dark Brown
- 7. Peach
- 8. Red
- 14. Light Green
- 15. Green
- 18. Light Blue
- 19. Blue
- 21. Lilac
- 23. Pink
- * . Any Flesh Tone

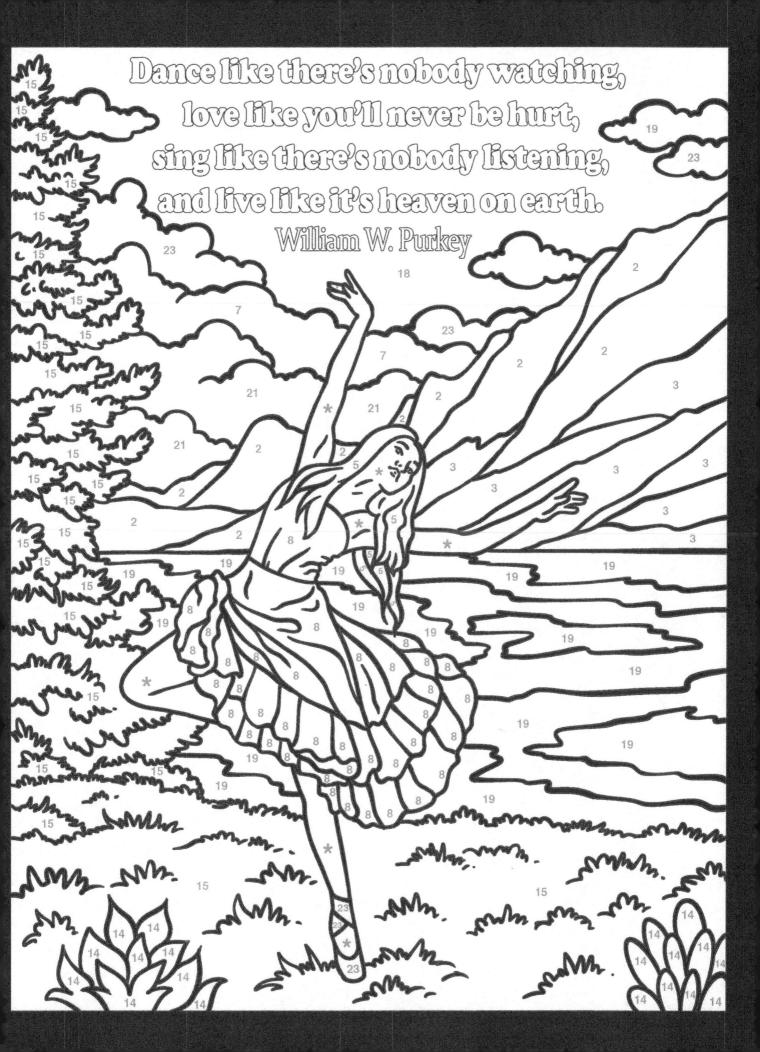

MANDALA BLACK BACKGROUND Color By Number

Anti Anxiety Coloring Book For Adult Relaxation

- 7. Peach
- 8. Red
- 10. Orange
- 12. Yellow
- 16. Dark Green
- 17. Aqua Green
- 18. Light Blue
- 19. Blue
- 20. Dark Blue
- 22. Violet
- 23. Pink
- 24. Vivid Pink

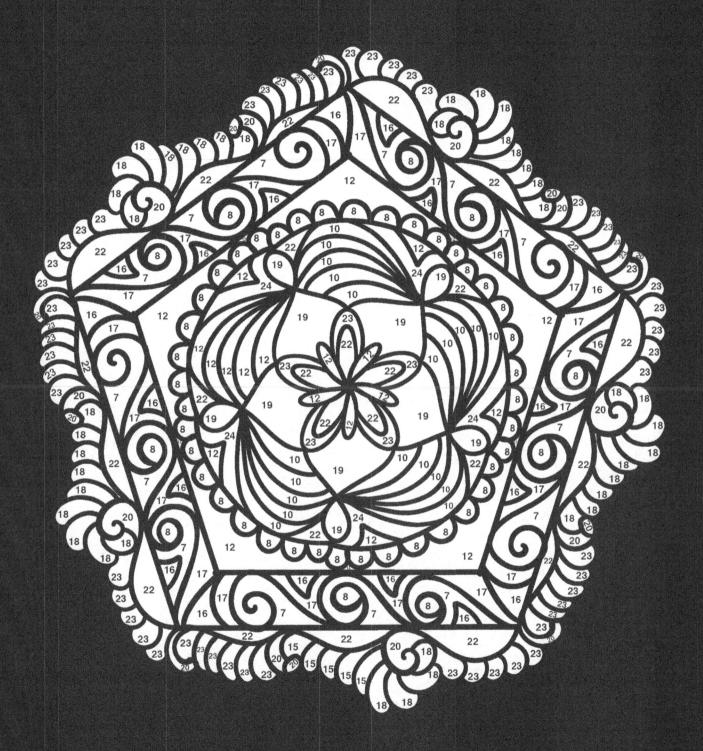

Spring Scenes BLACK BACKGROUND Large Print Color By Number Adult Coloring Book

- 1. Black
- 2. Gray
- 3. Dark Gray
- 4. Brown
- 6. Tan
- 7. Peach
- 8. Red
- 10. Orange
- 12. Yellow
- 13. Golden Yellow
- 15. Green
- 17. Aqua Green
- 18. Light Blue
- 19. Blue
- 20. Dark Blue

- 21. Lilac
- 22. Violet
- 24. Vivid Pink
- * . Any Flesh Tone

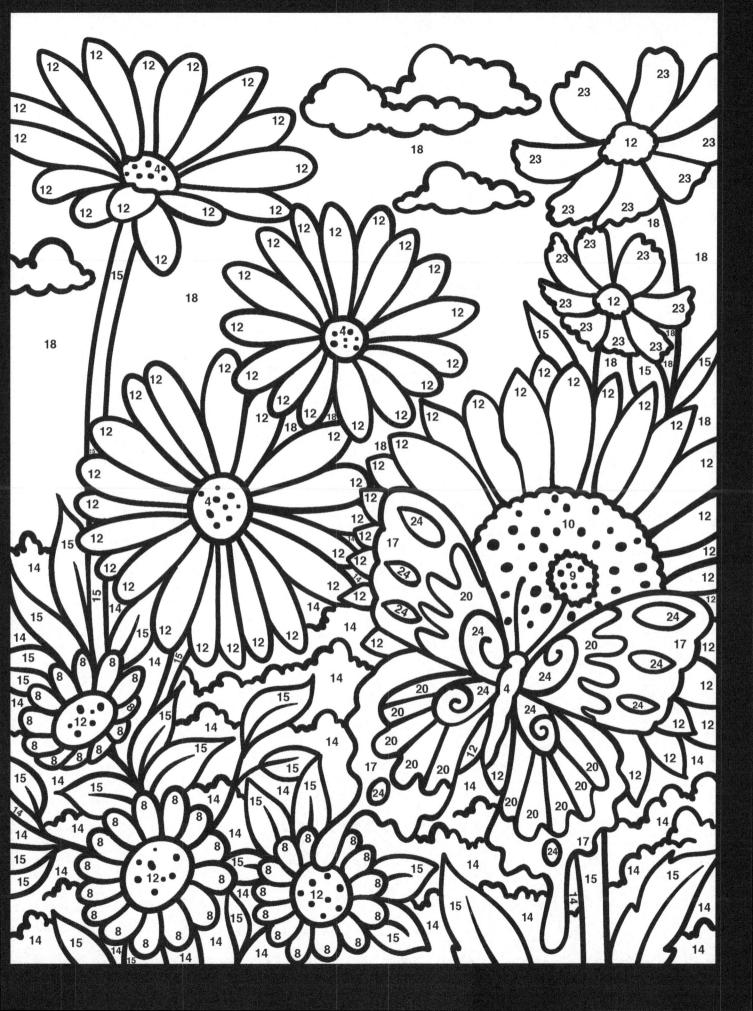

Highlight Reel

BLACK BACKGROUND
Color By Number

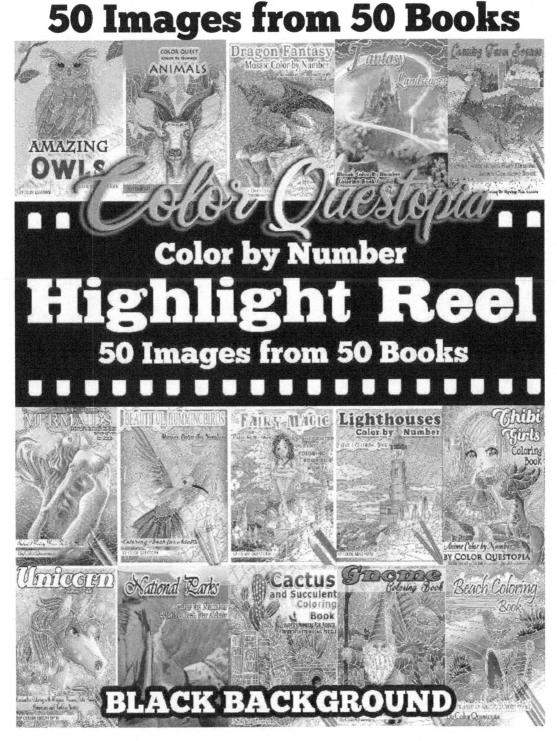

1. Black

- 16. Sky Blue
- 2. Dark Brown
- 17. Blue
- 3. Light Yellow
- 4. Light Orange
- 5. Light Brown
- 6. Medium Brown
- 7. Brown
- 8. Yellow
- 9. Green
- 10. Light Green
- 11. Dark Green
- 12. Dark Gray
- 13. Medium Gray
- 14. Gray
- 15. Light Gray

From: Fanciful Fox Mosaic Color By Number Book

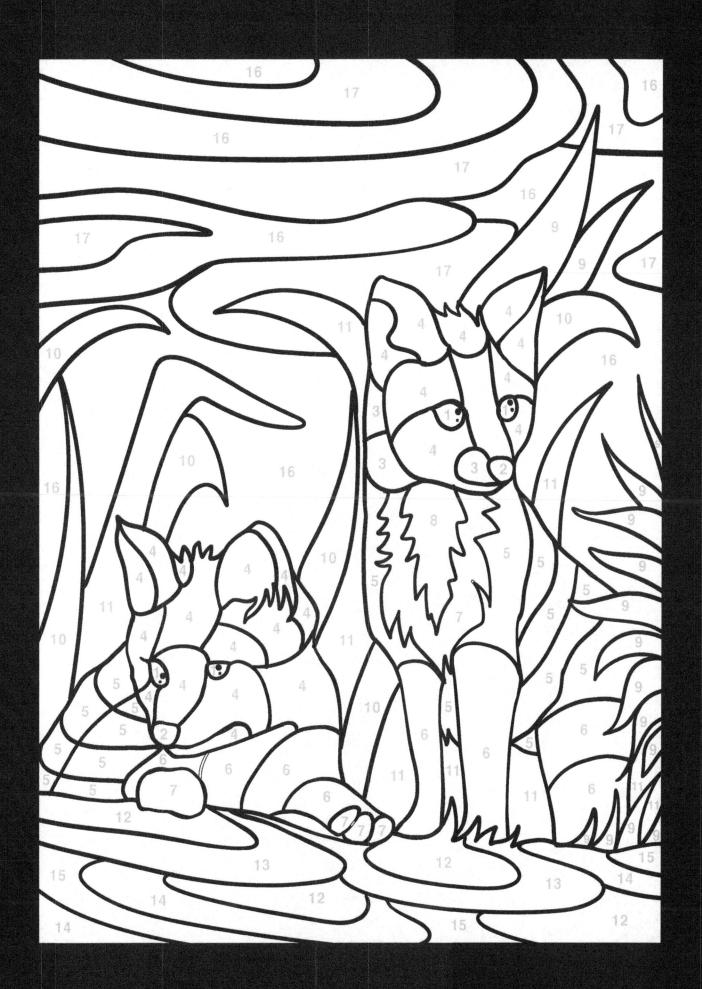

Gustom Color Chart

Medium:		Branc	d:
1.Black	2.Gray	3. Dark Gray	4. Brown
5. Dark Brown	6.Tan	7. Peach	8. Red
9.Orange Red	10.Orange	11. Light Yellor	12. Yellow
13.Golden Yello	14.Light Gree	15. Green	16. Dark Green
17.Aqua Green	18.Light Blue	19. Blue	20. Dark Blue
21. Lilac	22.Violet	23.Pink	24. Vivid Pink

Gustom Color Chart

Medium:		Bran	d:
- Shi 1.	2. 2. 2. 2.	3. Sys	4.
-Show 5.	*848 e.	-Sing 7.	-848 8.
- Sign 9.	- Short 10.	-Sh2 11.	\$\hat{12.}
\$\tag{13.}	14.	- Shi 15.	- Sh Z 16.
O .	30 18.	200° 19.	20.
21.	22.	·	24.
000	00-0		000

	•		

	, i				
				e • • • • • • • •	

Made in the USA Coppell, TX 16 May 2023

16899534R00050